HEARING VOICES,
SEEING THINGS:
A SERPENTINE
GALLERY PROJECT

SEVEN ARTISTS'
PROJECTS
EXPLORING
MENTAL HEALTH

BOB AND ROBERTA SMITH

and

JESSICA VOORSANGER

with

MEL BRIMFIELD & SALLY O'REILLY

KAREN DENSHAM

MANDY LEE JANDRELL

ANDY LAWSON

VICTOR MOUNT

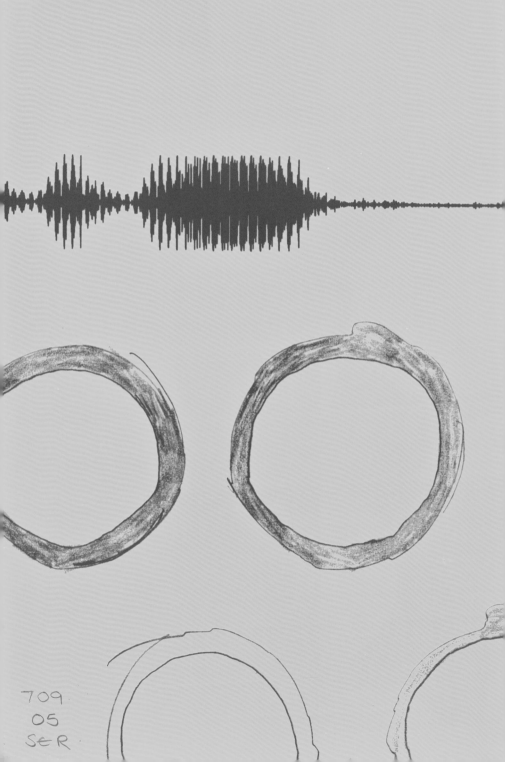

CONTENTS

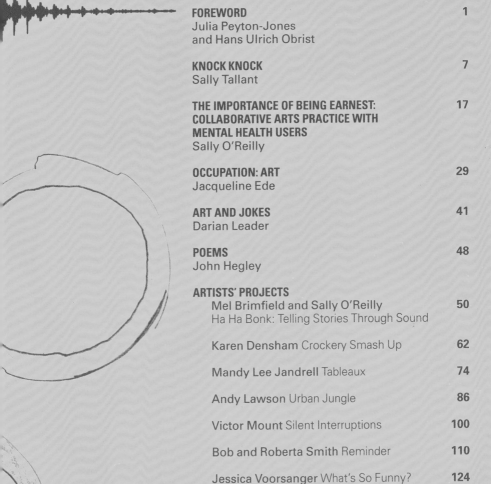

FOREWORD

Julia Peyton-Jones
and Hans Ulrich Obrist

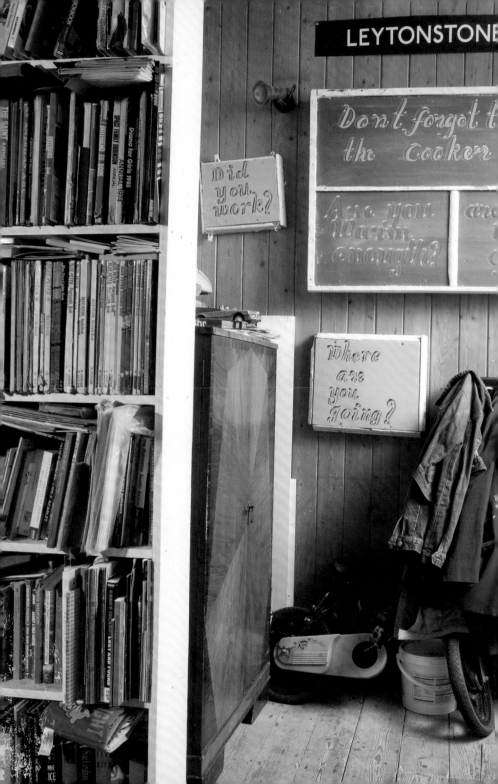

Bob and Roberta Smith
Notes to Self 2006
Photograph: Nicholas Moss

Hearing Voices, Seeing Things is one of an ongoing series of ambitious, large-scale projects initiated by the Serpentine Gallery through its Education and Public Programmes. Through this project and the Serpentine's association with Mind, the Gallery wants to help increase awareness of mental health issues. In 2004 the Gallery established a relationship with the Occupational Therapy Department of North East London Mental Health NHS Trust (NELMHT) to discuss arts provision across the four London boroughs served by the Trust: Barking & Dagenham, Havering, Redbridge, and Waltham Forest. From these discussions a project evolved that was to include artists' residencies, artist-led group activities, temporary events and an exhibition with the participation and collaboration of staff and service users of the Trust.

We are deeply grateful to artists Bob and Roberta Smith and Jessica Voorsanger who have shaped this project, and to participating artists and curators Mel Brimfield, Karen Densham, Mandy Lee Jandrell, Andy Lawson, Victor Mount, and Sally O'Reilly.

We are indebted to Jacqueline Ede, Lead Occupational Therapist for Arts and Rehabilitation, NELMHT, whose singular vision and unwavering commitment has been the foundation of the project's success. The Serpentine would also like to take this opportunity to thank all the staff and service users of NELMHT who have participated in the project.

We wish to acknowledge Alan Harris, Deputy Head Teacher, and Susie Thrift, Clinical Specialist Occupational Therapist, Brookside Adolescent Unit; Shaun Gastall, Senior Occupational Therapist, Waltham Forest Community Mental Health Team; Nicky

3

Jackson, Porters Avenue Resource Centre; Stacey Towler, Project Manager, and Glenn Mantle, Volunteer, Young Carers Project, Barking & Dagenham; Nicola Elliot, Senior Occupational Therapist, Lindsay Royan, Psychologist, and Bob Hammond, Manager, Petersfield Centre; the participants of the Hearing Voices Group, Redbridge; the staff at the Family Housing Association Mansfield Road; the staff at Morland Road Day Hospital, Dagenham; Mark Weston and the staff and service users of Waltham Forest Day Services and Kirkdale House, Waltham Forest Primary Care Trust.

Many of these projects could not have been realised without additional support. We are particularly grateful to the comedy producer Izzy Mant for her guidance with 'What's So Funny?', the comedy event that launched the project, and all the comedians who generously participated in it.

We are especially appreciative of Tamsin Dillon, Head of Platform for Art, and Cathy Woolley, Creative Communities Producer, for their work with the production and distribution of a poster series and postcard project across the London Underground network, specifically at stations in the North East London area.

Special thanks to Vivyan Ellacott, General Manager, Kenneth More Theatre, Ilford, and Denis Bird, Wedgwood, for their sponsorship support in kind of the projects 'Tableaux' and 'Crockery Smash Up'.

We are extremely grateful to the Trustees of the Rayne Foundation and the Big Lottery, without whom this project would not have taken place. We are indebted to Awards for All, whose funding has enabled us to document the project by way of this publication.

We are grateful to Bloomberg, who have been long-standing supporters of the Serpentine Gallery, and to the Royal Parks for their assistance with the project.

The *Hearing Voices, Seeing Things* identity, posters and publication were designed by Keith Sargent of immprint, whose involvement has been so in keeping with the spirit of the project.

We also wish to thank John Hegley for permission to reproduce his poems, and Jacqueline Ede, Darian Leader and Sally O'Reilly for their texts.

Finally we would like to thank our colleagues Sally Tallant, Head of Education and Public Programmes, whose vision continues to raise the level of ambition of Education Projects within the Public Gallery and Museum sector; Louise Coysh, Project Organiser, who has worked on the project from its inception; Catherine Hawes and Polly Brannan for assisting the artists; Matt Price, Publications Manager, for his work on this publication and Rachel Moss, Education Co-ordinator, for supporting the project throughout.

Julia Peyton-Jones
Director, Serpentine Gallery and
Co-director, Exhibitions and Programmes

Hans Ulrich Obrist
Co-director, Exhibitions and Programmes and
Director, International Projects

world , sha

war and heading in

came the mo

up of utopian designers v

ns of what the future cou

ne ready for this brave ne

new blockbuster exhibiti

rchitecture and design of

resent a 15-page G2 speci

ern movement. To begin

duces its key players – ar

many of their dreams sti

ed by

second.

rnists —

ɪ thrilling

hold. But ˅

world?

of moder

s at the V

elebrating

bert Hu

iscovers

rvive

Reminder 2006
Words and text from newspaper articles turned into songs and poems

KNOCK KNOCK

Sally Tallant

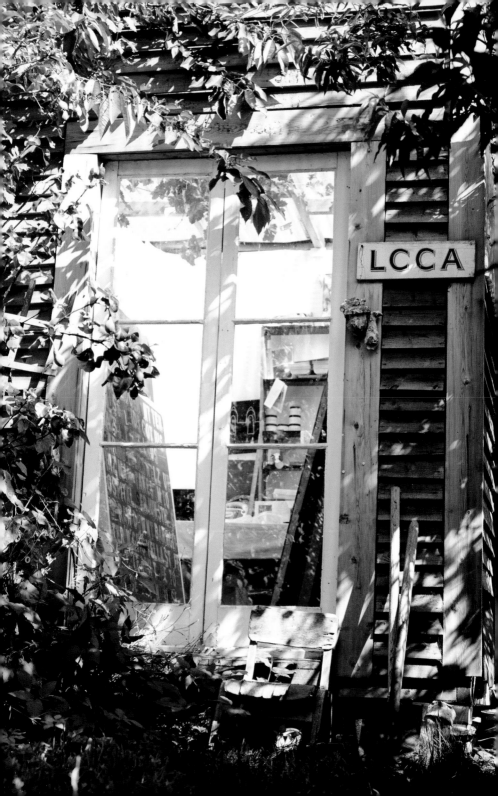

The Leytonstone Center of Contemporary Art
Photograph: Mandy Lee Jandrell

The Library
University College for the Creative Arts
at Epsom and Farnham

The relationship between art and life has long been explored by artists and is the place from which much contemporary art emerges. Since the 1960s artists have produced situations and objects that provoke a complex set of interrelations and dialectical relationships between artists, viewers and wider social contexts. They have been opening up a territory where artists and people can encounter art and in which situations and practices evolve. This complex territory is the ground on which the *Hearing Voices, Seeing Things* project builds.

If the division between art and life is removed and instead we focus on the act of making and the processes of producing objects and situations, it becomes possible to see that life and art are not two separate entities, but are continually creating and interacting with one another.

Many of the participatory and collaborative projects by artists in the 1960s and early 1970s provided structures in which active and passive, individual and collective, producing and spectating, ephemeral and durable were woven together. The powerful legacy of these works in constantly changing contemporary conditions calls for what pioneering Brazilian artist Hélio Oiticica referred to as 'increasingly open propositions'. The openness and reciprocity with which the artists and their collaborators approached *Hearing Voices, Seeing Things* has allowed an exploration of this shifting and contingent ground.

Hearing Voices, Seeing Things began as a series of conversations, firstly with Jacqueline Ede, Lead Occupational Therapist for Arts and Rehabilitation, North East London Mental

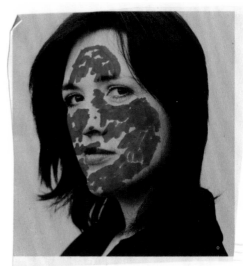

Health NHS Trust (NELMHT). Her desire to engage with the Gallery was met by that of the Serpentine to create opportunities for artists to make ambitious projects that challenge the conventions of where art can be produced and by whom. Following a year of visits to the Gallery, which established a basis for a more sustained residency, it became clear that a project could happen and that there was a commitment and desire on the part of NELMHT to make a residency possible.

Artists Bob and Roberta Smith and Jessica Voorsanger were invited by the Serpentine to be artists-in-residence at NELMHT. Together they founded The Leytonstone Center of Contemporary Art (LCCA), which is actually a garden shed. If, as they assert, a garden shed can be a gallery and everyone can be an artist, then there are radical possibilities for the social and political role of art and, in turn, of artists.

Conversation with Bob and Roberta Smith and Jessica Voorsanger led to consideration of how and why artists might accept the challenge of working in a mental health trust that is so geographically and socio-politically removed from the Serpentine Gallery. The question, which starts from the premise that art is socially and culturally produced, inevitably prompts other questions about the difficulty of production and what might constitute 'work' in these contexts. The added challenge of

engaging with people also meant that the project would become a testing ground for notions of authorship. That some of the people in this project are particularly vulnerable raised further issues. Smith and Voorsanger decided, therefore, to invite more artists to participate and the LCCA Outreach Group (LOG) was formed.

Meetings and conversations are at the heart of the project and the work was produced by means of this interaction. The immediacy and intimacy, as well as conviviality of these sites of production, has informed the work, and can be seen as much in the process as in the final work produced. The resulting exhibition presents a secondary audience (those who were not directly involved) with an opportunity to question and challenge their own preconceptions about mental health and the stigmas associated with the one in four people who need therapeutic support in their lifetime. It is the issues of normality and everyday mental wellbeing resonating through the work produced, as well as the humility and humour pervading this project that allows unspoken experiences to be articulated with clarity. This is where artists can play a crucial role – not as therapists but as artists equipped with a vocabulary and language that can help articulate the most challenging of realities.

If the 'subject' is constructed through language then it follows that the language explored through the seven projects that constitute *Hearing Voices, Seeing Things* is crucial. Language underpins communication, so finding a way to say something is perhaps the key to liberating subjectivity, especially for those who have difficulties with language. Through making, writing, looking,

listening, laughing and performing, each artist explored strategies for communicating and producing work.

Tableaux 2006
Photograph:
Declan O'Neill

There are many kinds of humour and laughter: hysterical, anxious or filled with despair; satirical, contemptuous or cruel; lighthearted, affectionate and convivial. The laughter that lubricates everyday social interaction has played an enormous role in this project. The telling of a joke – often a form of self-defence against fear and failure or a means of breaking the ice – has been used as a tool by Jessica Voorsanger, as a mechanism to communicate with a wide range of people. Jokes and comedy can be thought of as a way to stage experience, and this is explored in Voorsanger's stand-up comedy event, 'What's So Funny?'. In this context the transformative and subversive potential of art comes from the same source as that of laughter. Similarly, Sally O'Reilly and Mel Brimfield have employed comic strategies to tell stories. Rather than using spoken word, sound effects were employed as a way of expressing narratives, and low-tech Foley-artist techniques used to generate content. The idea of acting out and dressing up was central to Mandy Lee Jandrell's project; making use of theatrical costumes and props, she worked with a number of adults to create tableaux vivants.

For some of the groups and individuals the barriers to communication were more difficult to negotiate. Some find it hard to remember things and yet memory dictates the way we define ourselves and how we engage with the world. For those who experience memory loss, the ability to recall aspects of oneself is often lost, and this served as a starting point for Bob and Roberta

Tableaux 2006
Photograph:
Declan O'Neill

Smith's project 'Reminder', conducted with older people from
Petersfield Dementia Centre. Signposts were created that remind
us of who we are, where we are and what we need to remember
to do. Whilst language loss within this group was challenging,
each member of the group that Victor Mount worked with
experience a polyphony of voices. Members of this group, the
Hearing Voices Group, all experience voices, and within this group
those voices were acknowledged. For the artist, who remains
outside of this experience, the challenge becomes that of
translating and making work from this experience; not the
experience of hearing voices but that of not hearing them and yet
being part of this group.

 Two of the groups involved in the project were young
people who are all affected by mental health problems in very
different ways. Brookside School is an adolescent unit to which
young people are referred, providing a safe and therapeutic
environment for learning. Karen Densham worked as artist-in-
residence there and invited the young people to create and then
destroy ceramic plates and cups. This legitimisation of a violent

**Bob and Roberta
Smith**
Notes to Self 2006
Photograph:
Nicholas Moss

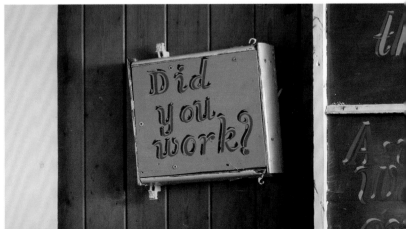

and destructive act seemed both appropriate and liberating for this particular group. The Young Carers from Barking & Dagenham worked with artist Andy Lawson in their time off from being carers for other people. Together they created work that looked at their world outside the significant responsibilities that they carry on a daily basis. The images that they have created reveal beauty in the details of their everyday environment.

The discussion about the therapeutic role of art is an unavoidable and challenging subject for artists working in a mental health trust. When art meets mental health it raises questions about what is possible and what is not. The rupture of everyday normality and its juxtaposition with artistic creativity leads to both volatile and exciting possibilities. The notion of normalcy and what mental health might mean for all of us quickly became a key concern. The artists were charged with the task of being artists and not therapists, while the therapists took on the role of clinical and therapeutic support. On a fundamental level, the project was about a meeting of people and has been an interesting and useful opportunity for everyone involved. The artists, the health professionals and the participating individuals who use the various services provided by the Trust have discovered what can be achieved by working together.

Sally Tallant
Head of Education and Public Programmes,
Serpentine Gallery

'What's so funny?'

Please fill in the space below with details of what amuses you.
Describe a scene from a film, tell a joke or an experience that you
found really funny.

I went to see my doctor today
He said "I haven't seen you
for a while".
I said, "I know I've been ill

Name (optional)

Date

hearing
voices
seeing
things

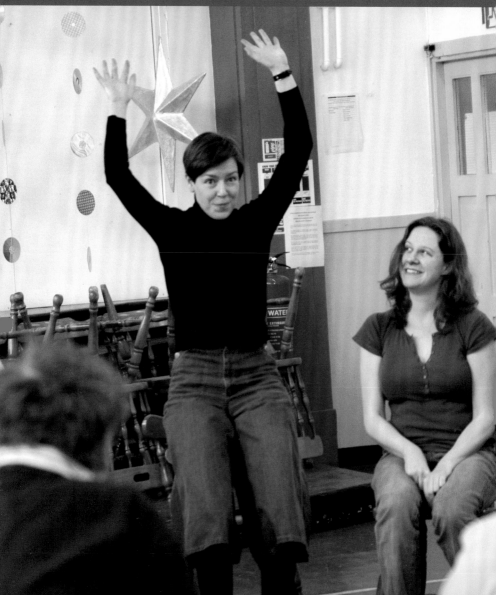

THE IMPORTANCE OF BEING EARNEST

COLLABORATIVE ARTS PRACTICE WITH MENTAL HEALTH SERVICE USERS

Sally O'Reilly

In the art world mental health is often viewed in terms of the curious drawings, perverse sculptures or unsettling texts made by patients, rather than the experience of a condition itself

As professional art practitioners of one sort or another, I imagine all of us involved in *Hearing Voices, Seeing Things* have looked at outsider art at some point. Those who visited the recent *Inner Worlds Outside* exhibition at the Whitechapel Gallery might have been struck by how inventive and bittersweet the artworks were, or by their unconventional perspective, in both the visual and conceptual sense of the word. Perhaps we perceive in outsider art a freedom from the constraints of the art establishment, coveting its unfettered naivety in contrast to our own, often paralysing, knowledge of art history. Or we might occasionally leaf through *Raw Vision* magazine, finding the craft aesthetic useful for thinking of new solutions to our own problems in the studio. However, although we may marvel at the contingent approaches of those less burdened by formal art education, the chances are that we would have overlooked the mundane difficulties that constitute the life of an 'outsider'.

In the art world mental health is often viewed in terms of the curious drawings, perverse sculptures or unsettling texts made by patients, rather than the experience of a condition itself. Mania, melancholia, existential angst and myriad other psychological states have come to be represented by aesthetic or intellectual tropes and motifs. Think of Edvard Munch's *The Scream*, for instance – an expression of intense anxiety that has now become a pub sign, heralding manic conviviality on a Friday night. From the point of view of the general public, the idea of artists and mental health patients working together is often shrouded in misnomers and mythology. In the Romantic tradition,

before the modernists realigned the artist with society and recast him as a useful citizen, the painter or sculptor was perceived as an outsider himself, perhaps even a frenzied genius chosen by God. But, as Bob Smith points out, 'Vincent van Gogh was a great artist driven to suicide by his illness, not a mad genius.' But then mid 20th-century portrayals of expressionist painters – Hans Namuth's film of Jackson Pollock is a prime example in my opinion – reasserted the mad genius stereotype, adding the extra macho spin of the lone wolf, an outsider by choice. And unfortunately, despite redoubled efforts since the 1980s to establish the idea of art as culturally, socially and politically embedded, the outsider character still persists to an extent, compounded by the image of the 'crazy' art student and the eccentric *bricoleur*. Those of us who work in the arts, however, know just how business-like, level headed, logical and responsible most artists have to be these days. Artists provide for families, work in institutions, head steering committees and

What's So Funny?
2006
Video still:
Polly Brannan

No amount of empathy can dissolve the barrier between observation and experience

generally practise citizenship according to the status quo. Artists are not outsiders, but are charged more with the task of transgressing certain boundaries, passing repeatedly between inside and outside to challenge their apparent fixity.

What *Hearing Voices, Seeing Things* required was an immersion in the reality of less picturesque or literary sounding conditions and a willingness to transgress inside and out in a way that was more empathetic than confrontational. We were asked to collaborate with NHS mental health service users – people who would be unlikely to know of such art-historical matters – to work within the structure of their day-to-day lives and instigate and oversee an entire process of creativity that would produce something that could stand on its own two feet in an internationally reputable gallery. Although a participatory approach sounds like the only decent and proper way to go about this, it creates its own hornets' nest of social and political awkwardness. We did not wish to simply stride in, run a few sessions and then walk away with the results. On the other hand, the project would inevitably come to an end, and our lives and theirs would continue much as before. Like the double bind of the anthropologist, no amount of empathy can dissolve the barrier between observation and experience, and so no matter how much time was spent with the groups, it was still a case of 'us and them'. I guess the point

What's So Funny?
2006
Video still:
Polly Brannan

of *Hearing Voices, Seeing Things*, though, was to reduce the dualism, however imperceptibly, and facilitate a cross-pollination that benefited both parties: access to the arts and therapeutic activities can clearly benefit service users, while an insight into worlds that are entirely removed from the conceptual, historical and commercial aspects of the contemporary art world can be equally important for any artist questioning the hegemony of such structures.

With this symbiotic goal in mind, it was crucial for the artists to convey that this project was not a process of exploitation, that we were not simply using people to passively provide content for our artworks and thereby further our own careers. This concern was vocalised by some service users – perhaps an understandable misapprehension considering the undertow of paranoia experienced by some – but to assuage this fear is not easy, as there is no universal emollient to cut through the complex layers of mistrust built up over a lifetime. The artists speak, though, of their amazement at how most people were eager to dive in, setting aside scepticism, allaying torpor or overcoming shyness in order to contribute to the group effort.

The net result, if not absolute trust, was certainly a willingness to negotiate a way forwards.

A certain fluidity of form and consequent space for negotiation makes art a useful tool for constructive dialogue and therapeutic activity. A significant difference between making art and, say, accountancy is that while there is a consensus on how to do bookkeeping, there is no such agreement about how to make a piece of art. The subjectivity of art is like an elasticated waist – it can fit most girths. Imagine, on the other hand, a workshop in accountancy: inventiveness would require an enormous amount of previous knowledge as its systems and processes have been formulated and fixed over century-long cycles of revolution and regulation. Often an art workshop involves some discussion of what art actually is, can be and should be. But while the layman in the

pub notoriously always asks, 'yes, but is it art?', interestingly, participants in *Hearing Voices, Seeing Things* were much less likely to question the validity of our proposed activities. Perhaps, if mental illness can be thought of as the loss of a sense of the normative, it would appear to create a certain freedom from

negative restrictions. In any case, many of us felt a refreshing liberation from the pressures of legitimisation.

This is not to say, however, that making work together was a radically unfettered procedure – it was often fraught with problems and issues. Victor Mount commented on how some members of his group, several of whom have suffered personal trauma or severe mental and physical abuse, struggled to engage with the project. In such situations we arrive back at the problem of how to incorporate the service users' voices into an artwork without simply treating them as subject matter, without taking them out of context and presenting them as case studies for a savvy gallery going crowd. If the aim, as Mel Brimfield identified, is 'a meaningful way of giving a voice to a frequently annexed section of the community,' how do you represent a reluctant or silenced voice?

This is the crux of empathy, of understanding who we are dealing with and regarding their situations not as anecdotes but experiences. But if the point of the project is to reflect the concerns of these people and their concerns are so abstractly diffident, the artist is left with a peculiar conundrum: how to communicate a lack of communication. Language, however, is very adaptable; it can speak of itself as accurately as it can speak of other things. Group members would regularly make a joke or a serious point delivered with dry irony that was a reflection on their own illness. Often, in the conversational scripts written by members of the group with which Mel and I were working, there would be some comical allusion to hospitals or medication. It was

If mental illness can be thought of as the loss of a sense of the normative, it would appear to create a certain freedom from negative restrictions

difficult during these moments for us, as the outsiders, to know how to react, as decades of political correctness have taught us to avoid direct mention of any condition beyond 'normality', instead employing some oblique and sterile sounding phrase. For the service users, however, these overt remarks provoked a collective wryness, the recognition that they had the right to address what the rest of society might not. This joke, told by David Berlevy, one of the group who were exploring humour with Jessica Voorsanger, is perhaps one of the most poignantly direct: 'I went to the library the other day and I asked the librarian if he had any books on suicide. He said "No, because people used to borrow them and never return them!"' This is the sort of joke that would send ripples of consternation through any public institution. What we learned through this project, though, was to laugh with alacrity, to empathise without patronising and, what is more, to facilitate artworks that not only look or sound like art, but also follow the contours of the lives of those who made them.

Sally O'Reilly is a writer, lecturer and co-editor of *Implicasphere*.

OCCUPATION:
ART

Jacqueline Ede

Victor Mount
Home Repair Kit (detail) 2006
Photograph: Declan O'Neill

'Without freedom, no art; art lives only on the restraints it imposes on itself'

(Albert Camus, *The Outsider*)

Who are you calling an Outsider?

Since 1972, mental health service user artwork has been categorised as 'outsider art'. This term, formed by historian Roger Cardinal, applies to art objects that belong to no movement or school and are made by people who have no supposed artistic background. The suggestion is that outsider artists have had no formal training and therefore show purity of expression. However, the phrase can be misused or misunderstood, and is felt to be offensive to many individuals, particularly those who use mental health services and often experience daily marginalisation from society. According to current British statistics, one in four people will suffer with a mental health problem during their lifetime. It follows that this will include a quarter of all artists too, whether they have had a conventional training or not.

Working in partnership with the Serpentine Gallery was born out of recognising the appetite for creativity in the mental health service user community, and the frustrating inability to access the mainstream art world. Determination governed the lengthy process of telephoning over forty arts institutions before the Serpentine Gallery, alone, responded with enthusiasm for a joint venture.

The *Hearing Voices, Seeing Things* project has enabled progress through barriers of stigma and typecasting, initially via service user-led mental health awareness training for the artists involved. With the open-minded approach of the Serpentine Gallery, *Hearing Voices, Seeing Things* has reached beyond the negative associations of outsider art. It has also challenged clinical practice. For example, artist Karen Densham's project 'Crockery Smash Up' enabled young people at Brookside, Goodmayes to literally break through health and safety restrictions for a day by throwing golf balls at their self-designed ceramic plates.

Rather than considering mental health service users as 'outsiders', perhaps 'free artists' would be a more fitting description of those making their own work beyond traditional routes.

Images: *Crockery Smash Up* 2006
Photographs: Declan O'Neill

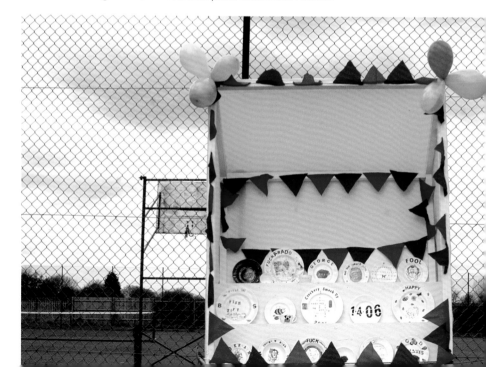

'For the most part, the activities of daily living are as ordinary and homespun as blueberry pie. There is little that is dramatic or glamorous for the individual in making a bed, taking a shower… or decorating a ceramic pot'
(Cynkin & Robinson)

Occupational Therapy for all?

If Tracey Emin had not got out of her bed where would she be? We are occupational beings reliant on carrying out basic tasks for our very survival, but shouldn't there be more to it than washing, eating and sleeping? For us all, a healthy occupational balance ought not to include just customary routines but also the unusual and infrequent events that are part of the texture of life.

Realising hopes, dreams, strengths and potential can facilitate recovery from mental illness. As the Occupational Therapist Dr. Mary Reilly said in 1962, 'Man, through the use of his hands, as they are energised by mind and will, can influence the state of his own health'. The therapeutic use of the arts is in no way new and can be traced back to ancient Chinese, Persian, Egyptian, Greek and Roman societies, in which having an occupation was advocated for improved health. Hippocrates, the father of modern medicine, prescribed artistic recreational pursuits for many occupations. Indeed, having 'Arts on Prescription' at GP surgeries is a recent Government initiative, yet it is as old as the hills, or at least Hippocrates, and came to prominence with the founding of the Occupational Therapy profession in the early 20th Century.

Moving on from stipulating what someone should do, *Urban Jungle* 2006
client-centred Occupational Therapists (OTs) encourage people to
engage in self-chosen activities. Individuals lead by prompting the
OT as to their interests. Involvement in their selected activity, at
the right pace and to the right degree, helps to decrease
unwanted symptoms and develops esteem, confidence and
occupational satisfaction. *Hearing Voices, Seeing Things*
endeavoured to provide extraordinary opportunities, widening
would-be participant options.

It is by freely engaging in tasks that hold purpose and
meaning for the individual that quality of life can truly be
enhanced. Andy Lawson worked with Young Carers aged 10 – 14
to explore the local Barking & Dagenham area with fresh eyes
and disposable cameras. The pictures pay testimony to their
newfound sense of the world around them and their place in it.

Urban Jungle 2006

*'If you hear a voice within you say "you cannot paint",
then by all means paint and that voice will be silenced'*
(Vincent van Gogh)

Is there an art to health?

What is health? The World Health Organisation's international definition describes 'a state of complete physical, mental, and social wellbeing, not merely the absence of disease or infirmity'. We all have our health to manage but how do we do it successfully? And how can those with enduring difficulties make sense of everyday?

In the UK, 16% of the population require access to mental health services at any one time; more than 95% of people in contact with specialist mental health services live in the community; one in five adolescents think so little of themselves that life does not seem worth living; 78% of depressed and suicidal young men have experienced bullying; 20% of people over 80 years old will develop dementia, the most common form being Alzheimer's Disease; and mental health problems account for the loss of more than 91 million working days each year.

Research has found that children in the poorest households are three times more likely to experience mental health problems than children in better-off homes, providing evidence of the relationship between disadvantaged circumstances and mental health problems. Deprivation is both a cause and a consequence of poor mental health. Furthermore, occupational alienation, injustice, disruption and deprivation are

Hearing Voices, Seeing Things

demonstrates social inclusion in action, with the tenets of empowerment and recovery at the heart of its ethos

routinely faced by many with mental health problems. These features are compounded by long-standing stigma and discrimination within society, resulting in greater stress, loss or lack of confidence, and breakdowns.

Hearing Voices, Seeing Things demonstrates social inclusion in action, with the tenets of empowerment and recovery at the heart of its ethos. This was illustrated by service users at the Petersfield Dementia Centre, Havering, who had to remind Bob Smith that he had forgotten the letter 'f' when they were involved in designing a brand new font!

Access to facilities at the Kenneth More Theatre, Ilford, proved highly rewarding for those who created their scenes and were photographed by Mandy Lee Jandrell in the 'Tableaux' project. Being able to use the stage, set, costume department, dressing and green rooms gave people a flavour of life in the performing arts first hand.

Victor Mount slotted into the Redbridge Hearing Voices Group with ease. Carefully listening to the advice and expertise of members, he produced a sound track that many identified with as being profoundly similar to their own experiences.

In Beacontree, 'Ha Ha Bonk: Telling Stories Through Sound' was written and created by a large group of participants with Sally O'Reilly and Mel Brimfield. It brought together a diverse group in terms of culture and background, from those still in hospital, living at home or homeless. A great deal of humour was had, not least at the all-boundary-crossing recording of going to the toilet! The series of Jessica Voorsanger's 'What's So Funny?' workshops in Waltham Forest also had people rolling in the aisles, suggesting that laughter is indeed the best medicine.

For many, *Hearing Voices, Seeing Things* provided a tangible sense of achievement through the production of high quality artwork, positively affecting both confidence and occupational satisfaction. This was part of the impact of *Hearing Voices, Seeing Things*, and may well be the art of health.

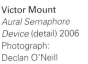

Victor Mount
Aural Semaphore Device (detail) 2006
Photograph:
Declan O'Neill

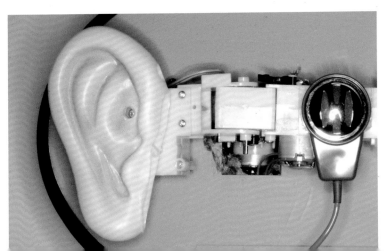

'I am an artist, I am here to live out loud'
(Emile Zola)

Making a Lot of Noise?

Bob Smith certainly did at an Older People's Day Unit in Dagenham East when a group conjured up lyrics from random news clippings for a keyboard and song session.

The idea of making a noise and being heard is certainly something positive to have come out of the project, and raises wider questions about matters of sustainability and progression. How can the momentum be kept up for service users in North East London and beyond?

Since *Hearing Voices, Seeing Things* started, *thinkarts* has begun. Launched in April 2006, *thinkarts* is run by and for service users to provide arts-related events, projects, and voluntary and freelance work opportunities. Members participate in activities, volunteer, enjoy paid work or receive permitted earnings (that protect benefit status). Funding has already been forthcoming from NELMHT and Capital Volunteering.

Producing the monthly *thinkarts* newsletter involves people taking journalistic and editorial roles by means of interviews, photography, feature writing, cartooning, layout and graphic design. It showcases member's poetry, creative writing, sculpture, painting, drawing and other art forms, and explores local initiatives to gather insights into how other artists work.

Commissions are accepted from all manner of organisations and individuals. Partnerships range from councils to

charities, trust boards to businesses. Members provide expert sessions to groups using their skills, teaching others how to see that their expressive voice is heard. Creative Circle open forums are held in local arts institutions for people to share ideas and meet like-minded people. The *thinkarts* website is a porthole for news on all the projects and displays a gallery of members' art.

All are welcome to join or request to work with *thinkarts*; this is a community-strengthening venture for individuals and organisations alike. In continuing to hear voices, see more things, and provide greater liberty, 'free art' is a way forward.

Jacqueline Ede, Lead Occupational Therapist for Arts & Rehabilitation, North East London Mental Health NHS Trust, and Director of *thinkarts*

Ha Ha Bonk: Telling Stories Through Sound 2006

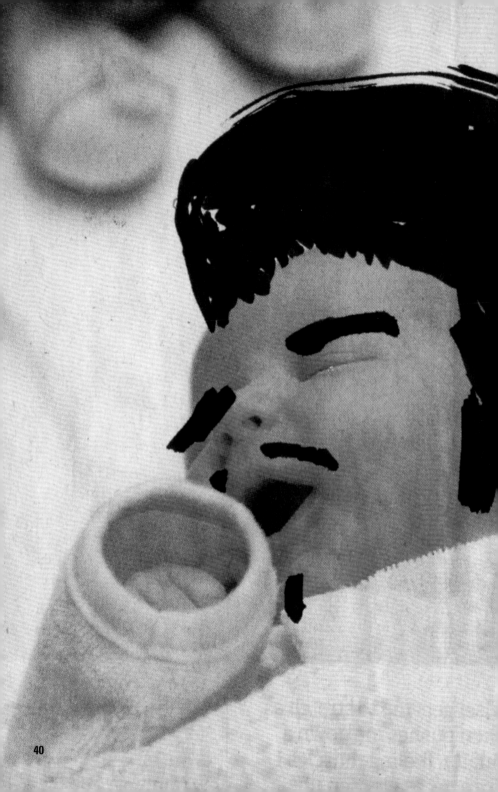

ART
AND
JOKES

Darian Leader

Comedy, humour and laughter are themes that run through many of the projects in Hearing Voices, Seeing Things. *For this publication, psychoanalyst and author Darian Leader was invited to write a text that considers how language shapes our relationship to art and humour.*

What do art and jokes have in common? Works of art are often described as funny or witty or comic, and sometimes they can make us smile or grin or laugh. They might involve a visual pun or allusion, or sometimes, as in the work of artists like Richard Prince or Bob and Roberta Smith, the actual presentation of a written joke, statement or question. In such cases, we often assume that it is the content of the work that makes us laugh: the written joke, the visual scene depicted, or the comic action of a video or installation.

Despite the frequency with which art is linked to humour, it is probably quite rare that we find ourselves laughing out loud suddenly, as we might do when we hear a joke. Jokes, after all, rely on the intimacy of two or more live human beings and the

Tableaux 2006
Photograph:
Declan O'Neill

shock of a punchline. Works of art, in contrast, can be viewed when one is on one's own and, in many cases, lack the temporal structure of verbal wit. Jokes allow us to distribute guilt, as we share for a moment an unconscious solidarity with the speaker. Whether works of art can do the same thing is unlikely, though not impossible. There's no reason why telling a joke can't be a work of art, for example.

While there are plenty of differences between the transitory community created by a joke and those created by works of art, art and jokes do have something in common. This is less to do with their content than with the relation between their content and their form. In the period when psychoanalytic approaches to art tended to focus reductively on biographical details, Ernst Gombrich once suggested that the best place in Freud's work to start thinking about art was his book on wit. No one seemed to take much notice of this remark at the time, but it is an intriguing and marvellous idea. A joke, for Freud, relied on a complicated mix of a message or 'tendency' (hostile, sexual, etc.) and the formal structures of language, the linguistic mechanisms that would give the joke its form.

A pun or double entendre relies, for example, on what a language has to offer in the way of similarities between words. Thomas De Quincey's neologism 'Anecdotage', for example, relies on the proximity of the words 'anecdote' and 'dotage'. Similarly, for one person to ask, 'Have you taken a bath' and the other to reply, 'Why, is there one missing?' presupposes the semantic ambiguity of the word 'taken'. These resources of

language can be exploited or brought out by the person telling the joke, but they are not invented as such.

In the same way, a work of art could have its 'message' or 'content', perhaps linked to the artist's biography and what happened to be going on in their head at the time they made it, but crucially, this would be moulded, shaped and structured by the language of art that they worked within. It is well known that what counts as art can change from one historical era to another, just as what seems possible or not possible can change with time. Rather than seeing artistic form as merely the vehicle of the artist's unconscious thought, as everyone else was doing when he wrote his article, Gombrich argued that Freud's theory of jokes showed how, as he put it, 'It is often the wrapping that determines the content. The code generates the message.'

This emphasis on the code is exactly where art and jokes converge. Some time before Gombrich penned his article, Lacan was developing his own theory of how jokes work, emphasising the linguistic dimension that Freud had put at the centre of joke dynamics. Lacan thought that jokes are about our relation to language, in the sense that language not only gives form to, but also distorts, our original intentions. To speak, we have to use codes that are imposed on us by our caregivers and their language. In this process, part of what we 'mean' to say is always lost. As we first make demands to those who care for us, they tell us, more or less, what it is we are asking for. Their code forms our message.

Just as language houses jokes, so culture houses art

Don't jokes rely on the same slippage of meaning? So many jokes are about asking for things and making demands – the matchmaker, the beggar, the shrewd businessman all show up ubiquitously in the jokes Freud discusses – and then having these demands distorted by the listener. 'Throw him out!' cries the magnate after hearing the beggar's moving tale of woe, 'He's breaking my heart'. The code, embodied by the listener here, distorts the message. In a similar way, the verbal composition of jokes involves a privileging of the dimension of meaning 'in between the lines'. But rather than marginalizing this slippage, it is given its dignity as, precisely, the joke. Language may work to scramble our messages, but at the same time gives a place to this scrambling in the form of jokes. A joke, in this sense, is a message about the code. It is a miniaturised version of how language works, how it distorts and shapes our meanings.

Artistic practice, as Gombrich suggested, shares this special inflection of the message by the code. Language here can mean quite literally the words of spoken or written language or simply the systems and conventions of any given artistic syntax. But there is also another aspect that is shared by art and jokes. By designating something as a work of art, it starts to inhabit a special space. A Coke can is no longer just a Coke can, and can be sold for thousands of pounds if it finds itself in the right place at

the right time. This opening up of a gap in the field of objects follows the same principle as the joke: it shows how reality itself is constituted. To inhabit the shared, social space, we have to make a number of sacrifices. Most importantly, we have to accept that this space is governed by conventions and systems of signs.

The making special of works of art is only possible given this privileging of convention, which is one of the reasons why art is expensive. It reminds us of the gulf between the world of objects and the world of signs. In that sense, art is a message inside the code about how the code works. Just as language houses jokes, so culture houses art. What a joke and a work of art have in common, then, is this quality of being that part of a system that shows what the effects of the system are. Civilisation sanctions art as a kind of message about itself, about the loss that makes it all possible. And hence, as Martin Kippenberger once pointed out, art is like a running joke.

Darian Leader is a psychoanalyst practising in London and a founder member of the Centre for Freudian Analysis and Research.

Ernst Gombrich, 'Freud's Aesthetics' (1966) in Richard Woodfield ed, *Reflections on the History of Art*, Oxford, Phaidon, 1987, pp.221-239.

Jacques Lacan, *Les Formations de l'Inconscient*, (1957-8), Paris, Seuil, 1999.

Martin Kippenberger, *I Had a Vision*, San Francisco Museum of Modern Art, 1991.

46

JOHN HEGLEY

'When dealing with mental health issues one attempts to be humane, illuminating and light hearted. A torch in a darkness, a porch in a storm.' (John Hegley)

For Therapeutic Purposes

I have not been quite right in the head.
Like a balding tyre
I've been losing my grip.
I have been given various medication
To help me cope:
Anti-depressants,
Anti-psychotics.
And my brother has given me
A skipping rope.

Mental Health Poem

When he went out of his mind,
We helped him find
The key to get back in.
It was behind the dustbin.
The one that had it in for him.

May 2002

In the doctor's reception the sign read:
Are you looking after someone over 65
with mental health problems?
I read the sign as:
Are you looking *for* someone over 65
with mental health problems?

Poet **John Hegley** was invited to contribute his poems for
this publication.

HA HA BONK: TELLING STORIES THROUGH SOUND

Artists:
MEL BRIMFIELD & SALLY O'REILLY

with
People at Porters Avenue Day Centre,
Dagenham

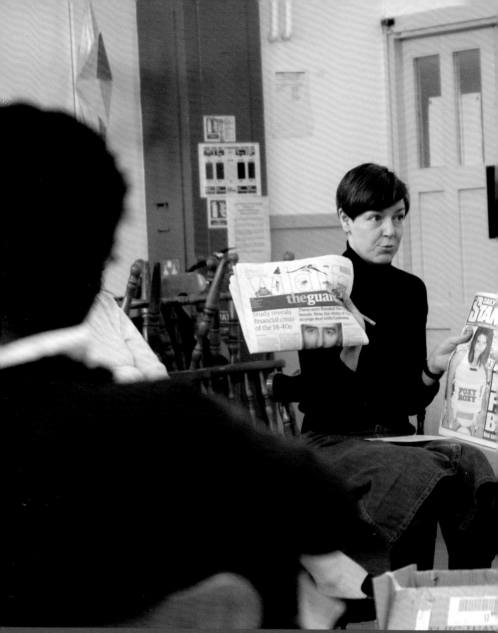

Ha Ha Bonk: Telling Stories Through Sound 2006
Photograph: Declan O'Neill

Noises and sounds affect the way we experience and understand our environment. For radio, TV, cinema and other media, the role of the sound effects department (or the 'Foley artists' who conjure up sound effects) is essential for maintaining the audience's suspension of disbelief

Ha Ha Bonk: Telling
Stories Through
Sound 2006

Listeners of the classic BBC radio programme *The Goon Show*, for example, will be familiar with the montage of absurd sound effects created in the studios, from a simple match being struck to spaceships landing and volcanoes erupting. These noises, mostly produced with an incredible economy of means, play a key role both in communicating the narrative and in heightening the comic effect. It is the relationships between narrative, sounds and humour that are explored in the project 'Ha Ha Bonk: Telling Stories Through Sound'.

Ha Ha Bonk: Telling
Stories Through
Sound 2006

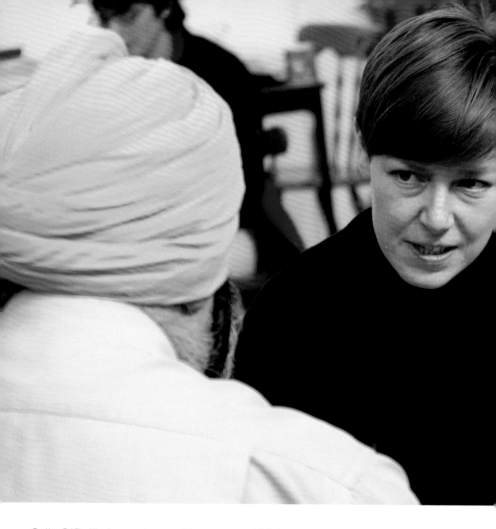

Sally O'Reilly is a writer and lecturer and Mel Brimfield an artist and curator, both of whom are involved in collaborative projects across disciplines, often working with writers, and performers. Using their experience of these fields, they worked with people at Porters Avenue to improvise and invent stories through spoken word and sound effects.

Ideas and subjects were drawn from a variety of sources. Reading articles in newspapers and discussing current affairs seen on the television provided a wealth of material, from

Images: *Ha Ha Bonk: Telling Stories Through Sound* 2006
Photographs: Declan O'Neill

lamenting the death of footballing legend George Best to paying homage to favourite pop stars. Others took inspiration from their own private lives and family relationships, such as a breakfast conversation between grandfather and grandson. Scripts and texts were devised, written, performed and recorded, and sound effects created to accompany them, meaning that the day centre was temporarily transformed into a radiophonic workshop.

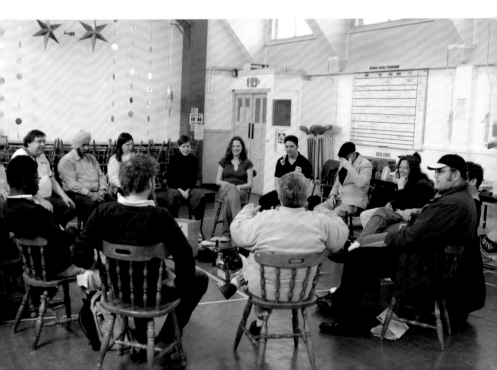

Dear Elvis

Come back you are missed!
I started out liking Bing Crosby
and I was in his fan club. I wonder
if you liked the army. You were
around before I was born.
You invented rock 'n' roll.
And your films are good.

Best

Stevie

Dear Elvis

Come back ~~back~~ you are

I started out lihing Bing

and I was in his f

Dear George

You drank a lot but you were alright.
You were a good footballer.
You should have stuck with Manchester United.
You looked good and your haircut was nice.
You played for Northern Ireland but
I am your Number One Fan
No groupies allowed.
Hope you're playing blinding
Beautiful game in the next world.

All the best.
Sorry about the pun.......

Pete, Chris, Steve + Bob

Dear Cliff

We are your biggest fans.

We come to all your concerts and we adored your last one.

In fact you could say we are like your shadows.

We have just come back from our summer holidays

and we listened to your music on the bus. We found

some money on the way home and it's finders keepers.

Well we are still bachelor boys and we don't have much

cash. But we'll save the best of it for you!

Glenn + Michael

Grandad — MORNING SON!

Dear Cliff

We are your biggest fans. We
come to all your concerts and we adored your last
one. In fact you could say we are like your shadows.
We have just come back from our summer holidays
and we listened to your music on the bus. We found
some money on the bus on the way home and it's
finders keepers. Well we are still single bachelor boys
and we don't have much cash. But we'll save the
best of it for you!

Glenn + Micheal

Dear Nora

I saw your last episode of last of the
summer wine, if

S: Morning Grandad!

G: Morning Son!

S: What's the time, my alarm clock's dodgy,

G: Quarter to, you're late.

G: Get your skates on, you'll be late for your paper round.

S: I'm so tired – yawn!

G: You need to go to bed a bit earlier!

S: Got some breaky.

G: Yeah, I'll do you some toast and cereal.

Pause.

S: I'll stick the kettle on, do us a brew.

Meoww!

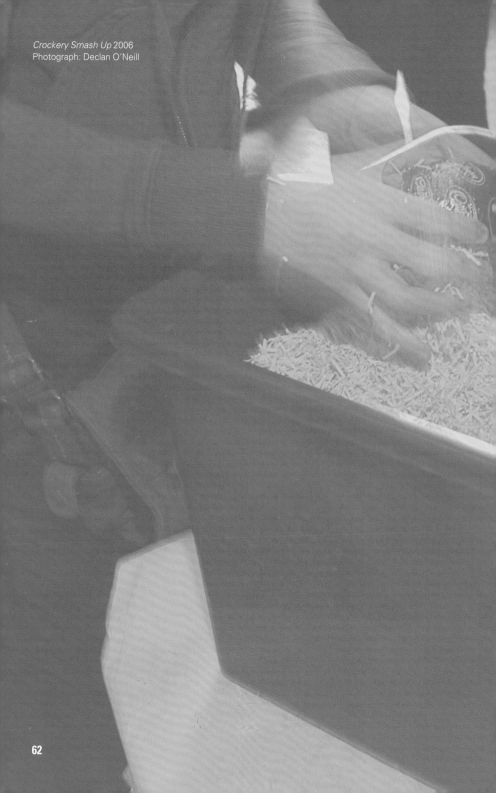

Crockery Smash Up 2006
Photograph: Declan O'Neill

CROCKERY SMASH UP

Artist:
KAREN DENSHAM

with

Young people from Brookside, Goodmayes

Images:
Crockery Smash Up 2006
Photographs: Declan O'Neill

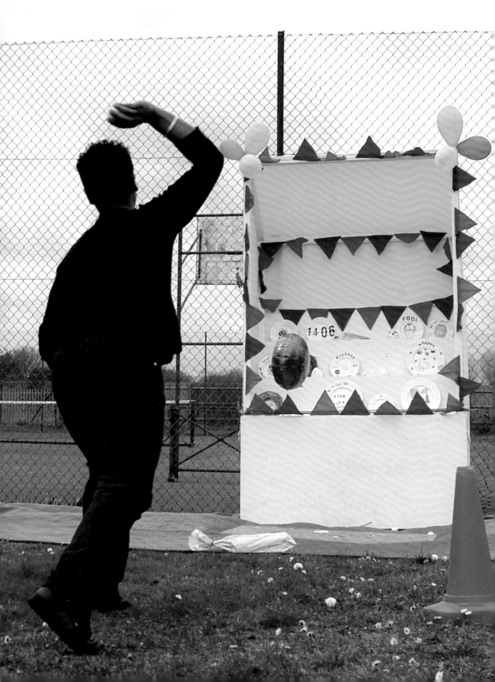

As a child you are constantly being told to 'look out,' 'behave,' 'be careful' and 'don't break it!' With this conditioning, we are made aware of the value of things and how our conduct can cause damage. While being warned, told how to behave and chastised is an essential part of the human learning process, so is encouragement, the ability to learn for oneself and the opportunity to express liberation from the rules from time to time. It can be a fine line between conditioning and repression, just as it is between letting one's hair down and behaving inappropriately.

With such ideas in mind, artist Karen Densham decided to work on a project in which young people could transgress the usual boundaries of acceptable behaviour and let off some steam by smashing up plates on a fete-style crockery shy. The Brookside staff enthusiastically embraced the idea.

Working with ready-made plates and cups, the young people created images with which to decorate them, using drawing and collage to reflect their likes and dislikes and the things they wished to celebrate or commemorate. Some people had clear ideas from the outset, with images of pets, messages for family members or loved ones, names of pop stars and scenes of London making regular appearances. Ones of which

the participants were proud were kept or given away as presents, while less successful attempts and plates featuring things people dislike (ranging from 'Chav' culture and political figures to the Devil) were racked up for imminent destruction.

Fine bone china was a material new to many of the participating young people, and from the start of 'Smash Up', the 'preciousness' of the material and the idea of it being destroyed was difficult for some to cope with. For others, the desire was to get down to smashing them up as soon as possible!

The final event of the project had the feel of a village fete. After a celebratory lunch, everyone at Brookside participated in this very public spectacle. The 'Smash Up' stall was decked with bunting and balloons, and loaded up with its fragile display. As fairground music played, each person took their turn at attempting to make a direct hit on their chosen target. Densham painstakingly reconstructed the shattered crockery to complete the project.

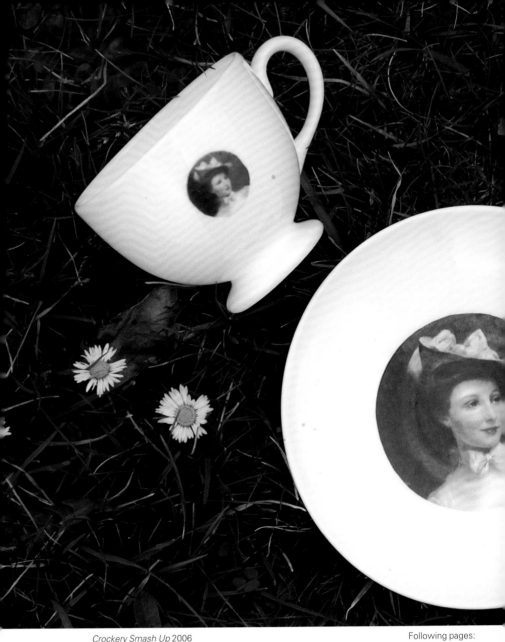

Crockery Smash Up 2006
Photograph: Declan O'Neill

Following pages:
Crockery Smash Up 2006
Photographs: Declan O'Neill

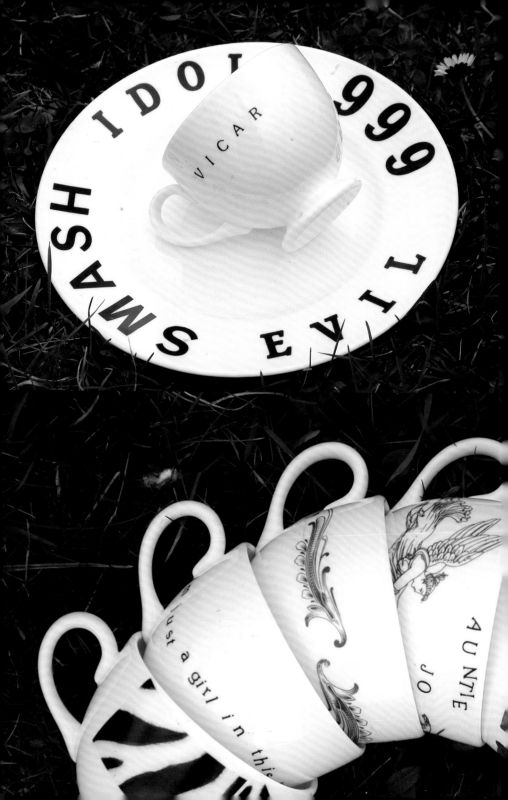

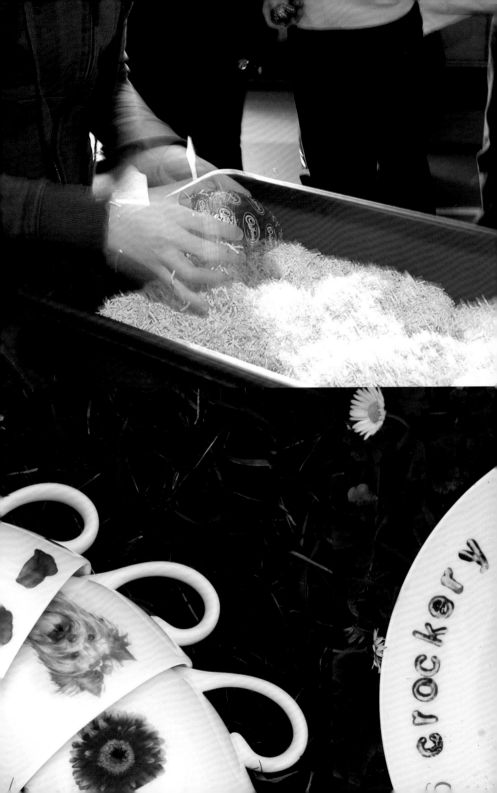

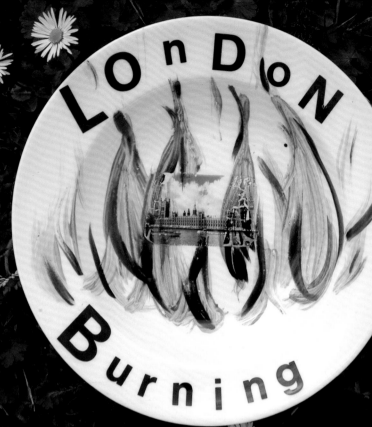

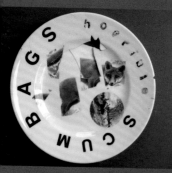
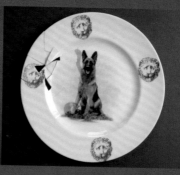
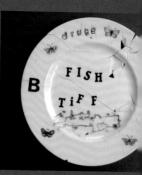

Crockery Smash Up 2006
Reassembled crockery
Photographs: Terry Bond

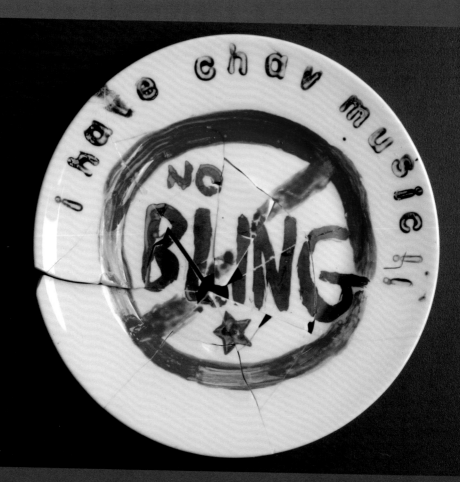

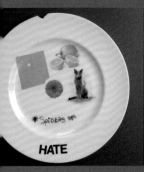

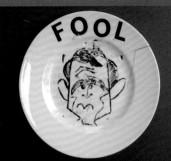

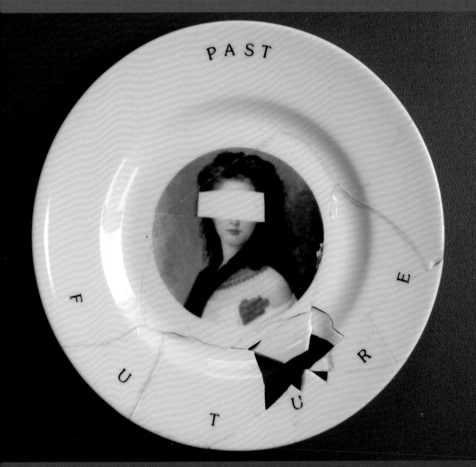

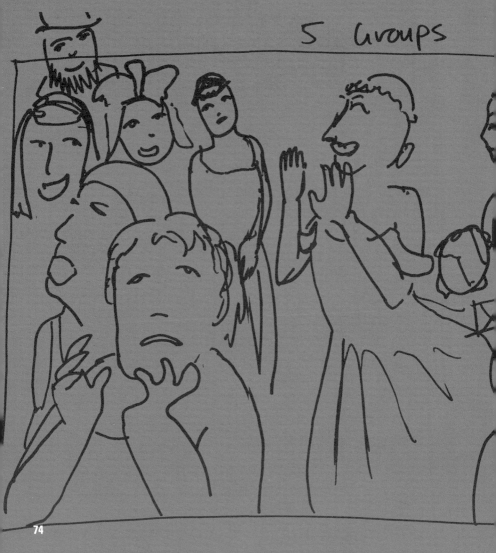

5 Groups

TABLEAUX

ople in each group.

Artist:
MANDY LEE JANDRELL

with

People from Redbridge, Waltham Forest
and Barking & Dagenham

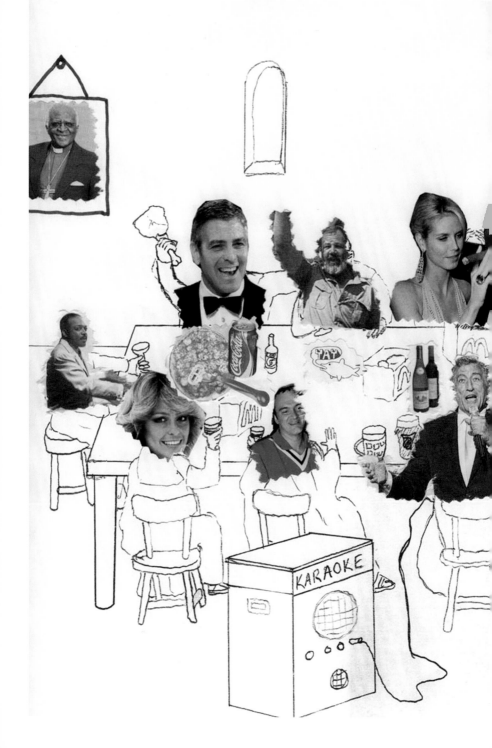

Glenn Mantle
Last Supper collage 2006

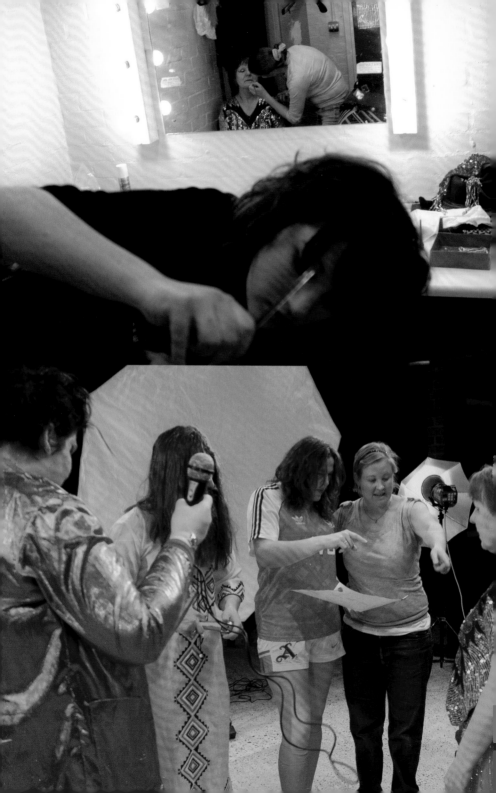

Images:
Tableaux 2006
Photographs: Declan O'Neill

Tableaux vivants, or 'living pictures' are scenarios in which a group of people is purposefully positioned on a stage or similar setting. The characters often wear costumes, and holding their positions, they stand motionless and in silence for the enjoyment of the audience. Originally a popular form of entertainment both in theatres and in drawing rooms, tableaux vivants were regularly based on paintings, drawings and engravings. It is thus an art form that crosses disciplines, marrying not only the theatre and fine art, but also later being incorporated into photography and film.

For *Hearing Voices, Seeing Things*, Mandy Lee Jandrell worked with a group of service users drawn from across NELMHT to develop their own series of photographic tableaux. Located in the centre of Ilford, the Kenneth More Theatre was an ideal setting for the project. The theatre's extensive costume department yielded characters ranging from knights and pirates to Egyptian princesses, providing an incredible treasure trove with which to fire up the group's imagination. Both historical and contemporary images informed the group's ideas, which were performed using a variety of props and recorded on Polaroid and medium-format cameras.

Images:
Tableaux 2006
Photographs: Declan O'Neill

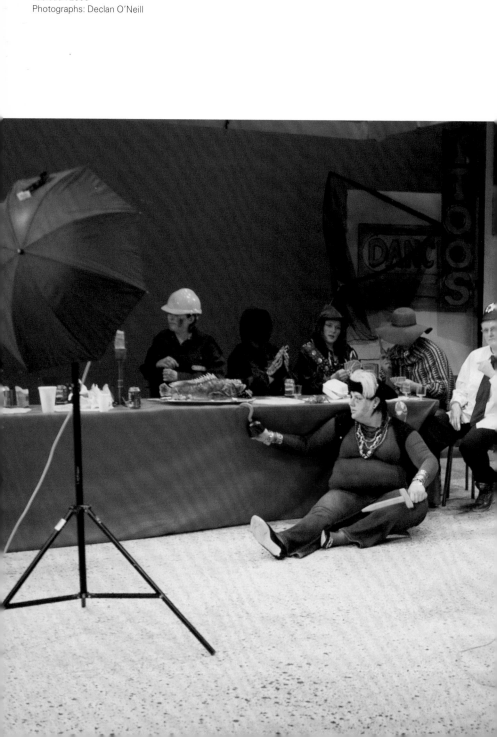

The participants were involved in all aspects of the creative process, from brainstorming initial ideas and making drawings and collages to developing ideas for the final scenarios. One tableau emerged from a collage composed of newspaper photos, while another idea was to create a scenario based on Michelangelo's *Last Supper*. As the project took place during pantomime season, the group made the most of a visiting company's stage set for a production of *Aladdin*. Additional props were gathered from a variety of sources, including joke shops and fast food restaurants, with every last detail taken into consideration.

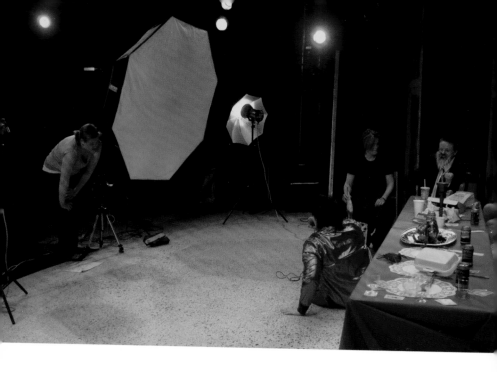

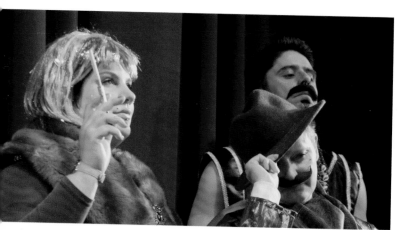

Images:
Tableaux 2006
Photographs: Declan O'Neill

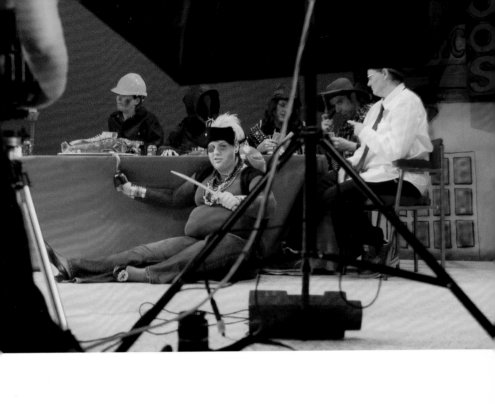
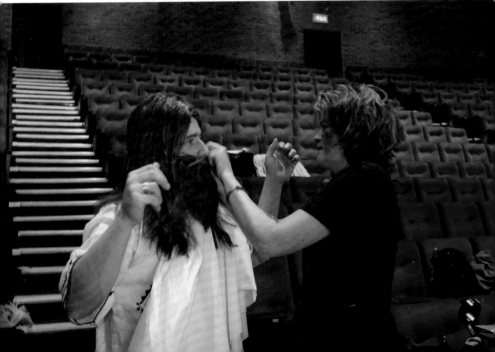

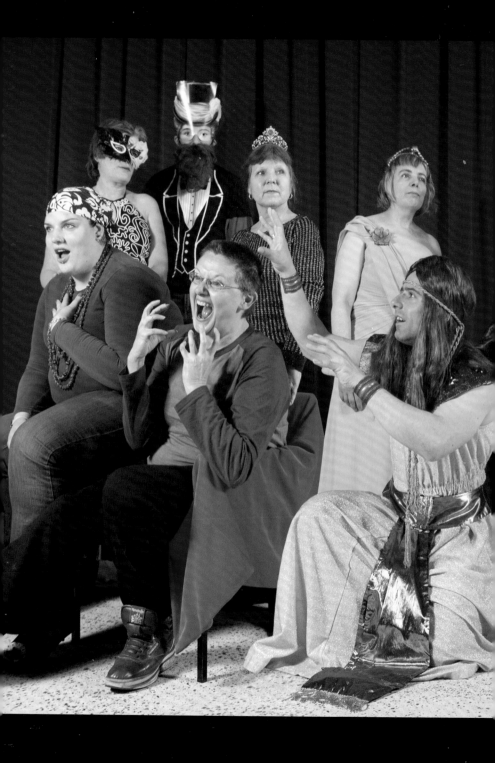

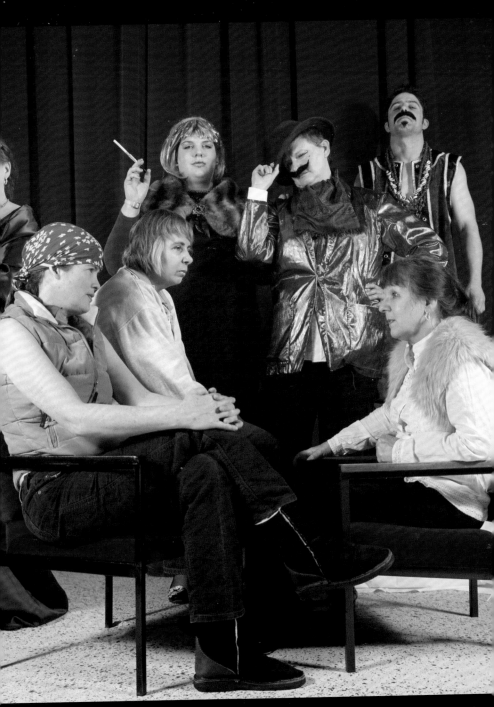

Mandy Lee Jandrell and participants *Tableaux (Collage)* 2006 Photographic montage

Urban Jungle 2006
Photograph: Declan O'Neill

URBAN JUNGLE

Artist:
ANDY LAWSON

with

Young Carers, Barking & Dagenham

Andy Lawson is interested in collections of objects that have been discarded or overlooked. Over a period of four years, he accumulated detritus that he found on the streets – from plastic toys to hair clips – which he now presents in a vitrine. In doing so, Lawson draws our attention to traces of everyday life and to evidence of the effects of time around us. Another project in which these concerns are demonstrated is Lawson's *Coffee Stain Collection*, in which he amasses stains left by spoons, carefully preserved on specially made Formica tesserae.

For *Hearing Voices, Seeing Things*, the starting point of Andy Lawson's project with the Young Carers Group was an expedition around their local environment. The Young Carers are a group of young people aged between 10 and 15 who care for relatives. Armed with digital cameras, they set off with the intention of 'revealing something that otherwise may go unnoticed'.

Over 200 hundred photographs were taken, and the time spent making decisions about which ones to include and which to omit was an important part of the process. The

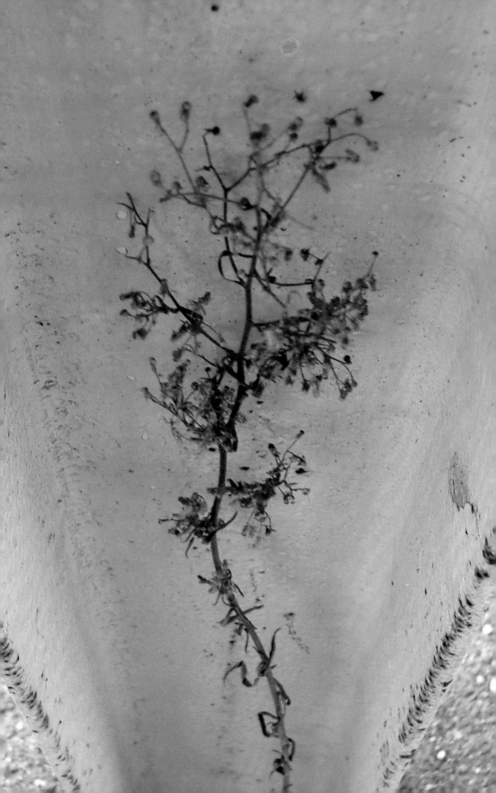

Images: *Urban Jungle* 2006

images selected by each participant were presented in an exhibition at their centre. Alongside these photographs, the group collaborated to produce and install large-scale abstract drawings derived from their images.

The work produced revealed much about each young person's own personal enquiry through the project and the beauty that can be found in unexpected places – from the peeling paint of a wooden fence to a weed growing at the base of a lamppost. Fresh perspectives can be found in familiar places, if only we take the time to seek them out.

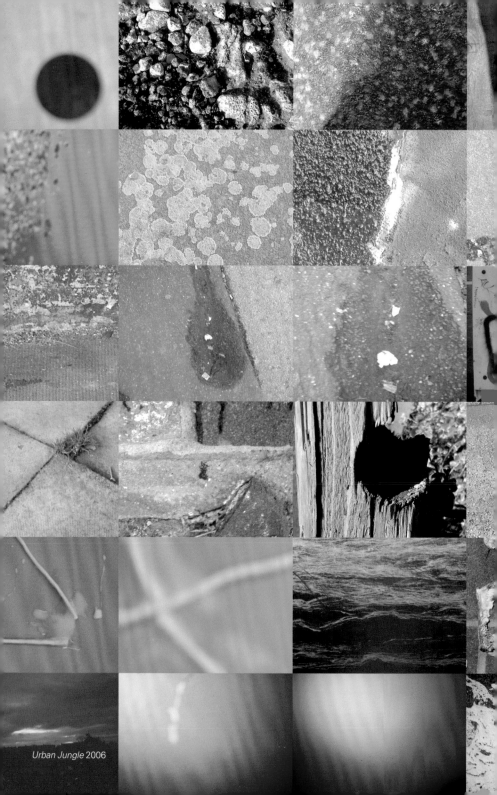

Urban Jungle 2006

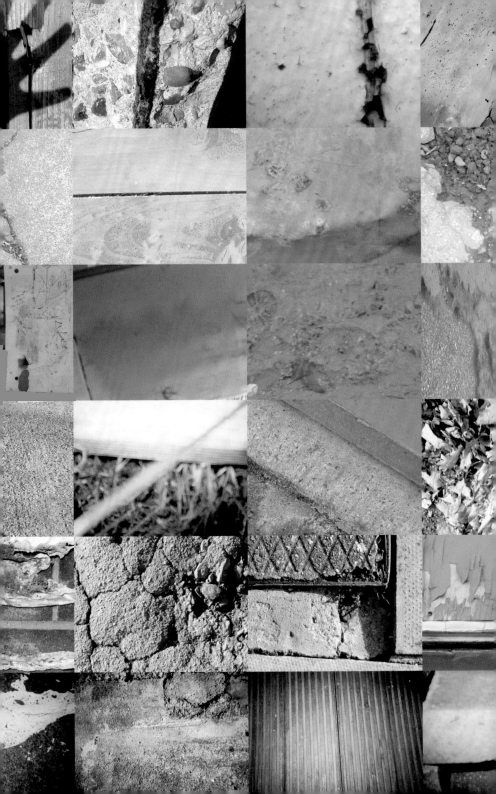

Urban Jungle 2006

Do as I say you evil little shit

Push him under the train

Victor Mount
Home Repair kit (detail) 2006
Photograph: Declan O'Neill

SILENT INTERRUPTIONS

Artist:
VICTOR MOUNT

with
Participants of the Hearing Voices Group,
Redbridge

Positive

God

Christ

Virgin Mary

Sex with ~~f~~ females

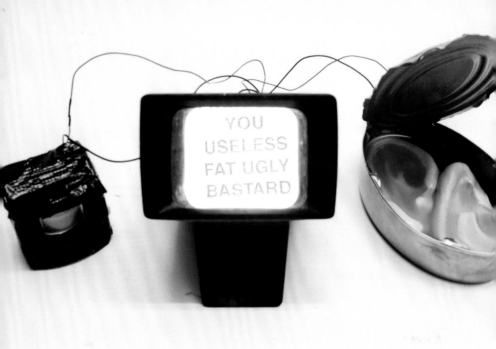

Victor Mount
Interpreter B 2006
Photograph: Declan O'Neill

Traditionally the 'treatment' for people who hear voices has been to use medication to suppress them; tackling the symptoms and not the cause. As a more sophisticated understanding develops about why people might hear voices, so too have the support systems centred on the individual.

Victor Mount became a regular visitor to the Hearing Voices Group (a recently formed group that preceded the inception of the *Hearing Voices, Seeing Things* project) to give individuals who hear voices the opportunity to meet with others and share their experiences. During these meetings Mount listened to peoples' personal experiences, seeking contributions from participants in an attempt to understand what it is like to live with voices.

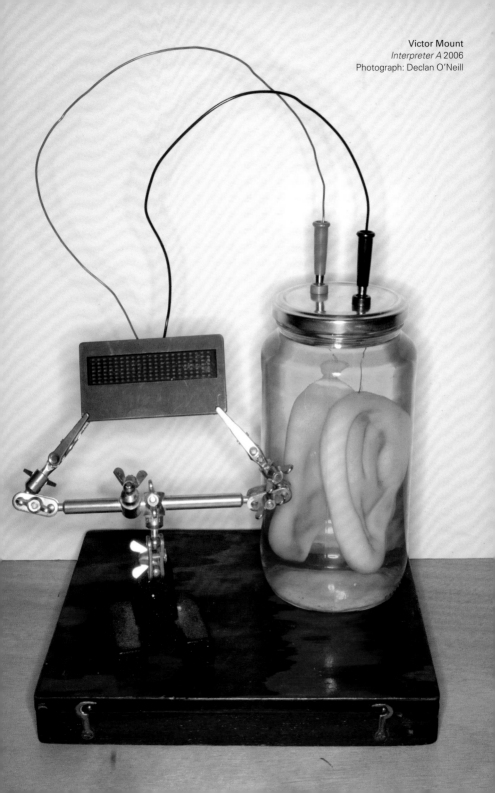

Victor Mount
Interpreter A 2006
Photograph: Declan O'Neill

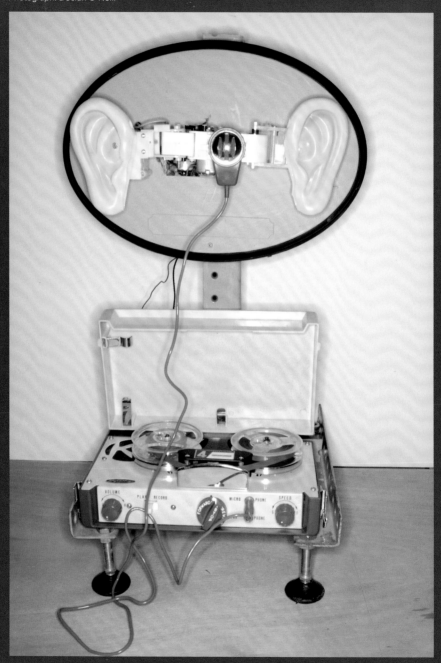

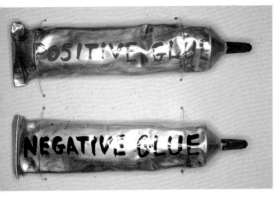

Victor Mount
Home Repair Kit
(detail) 2006
Photograph: Declan
O'Neill

Mount became interested in the ways in which people who experience voices attempt to respond to, silence or otherwise deal with them. During the course of the conversations he heard how people come up with their own methods to try to alleviate the symptoms and exchange tips with each other. Following on from this, Mount looked into 'scientisms' dating to the Victorian era and earlier – disciplines that sat between scientific research and amateur investigation, often resulting in curious theories and home-made medical inventions.

Informed by this, Mount made a series of new works, constructed from a variety of scientific and medical equipment and everyday household products, such as tin cans and shampoo bottles. A theme running throughout these assemblages is positivity and negativity, referring to the fact that people experience voices that can be constructive and destructive, amiable and abusive, docile and aggressive. The ear itself became a central motif in the work, serving as a kind of metaphor for the interface between inner voices and the 'outside' world. What results are assemblages that are affecting, challenging and even, perhaps, with an element of macabre humour.

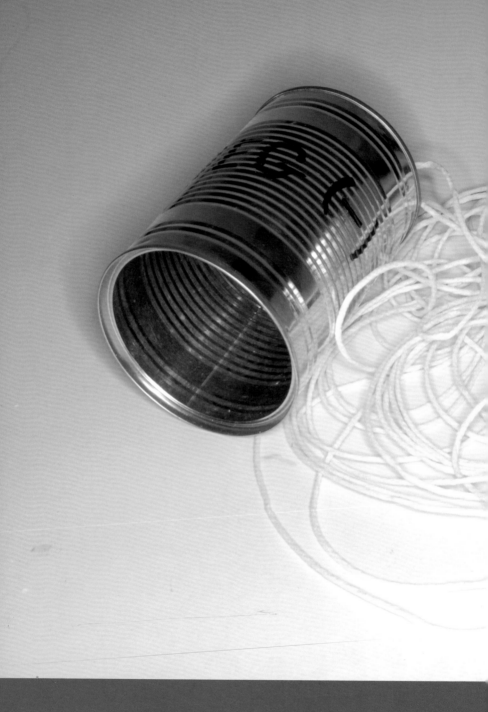

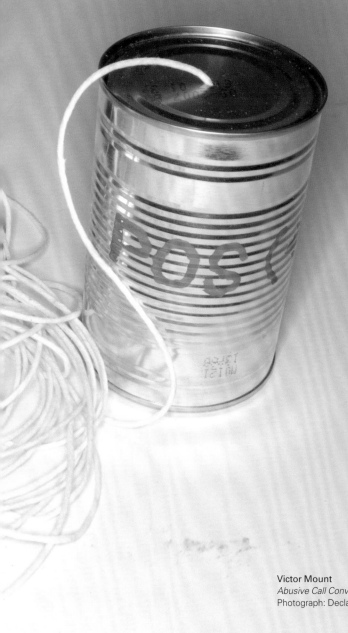

Victor Mount
Abusive Call Converter 2006
Photograph: Declan O'Neill

ONLY HAL

E ALL HI

REMINDER

Artist:
BOB AND ROBERTA SMITH

with
Older people from Petersfield Dementia
Centre, Havering and Morland Road Day
Hospital, Dagenham

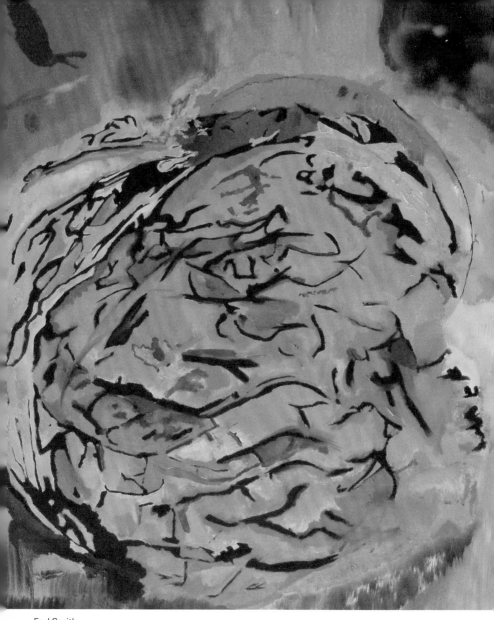

Earl Smith
Green Brain 2006
Earl Smith, who has memory problems,
assisted at a session of *Reminder*

'Were you married?' 'Did you have a job?' ask Bob and Roberta Smith on a series of hand-painted signs produced as part of the 'Reminder' project. As prosaic as these questions may seem, they hint at a more serious concern: what happens to our sense of self when we can no longer remember?

We define ourselves and others through the experiences that shape us. A sense of self, therefore, is to a large extent dependent on our ability to recollect these experiences, and on our ability to communicate them through language. It is the relationships between identity, memory and language that form the basis of 'Reminder'.

During the project, Bob and Roberta Smith worked with older people at the Petersfield Dementia Centre, and Morland Road Day Hospital. Using old newspapers, bric-a-brac and a set of assorted antiquated letter blocks from a printing press to act as prompts, sessions evolved that included discussions, reminiscences, drawing and the arrangement of objects, singing and story telling.

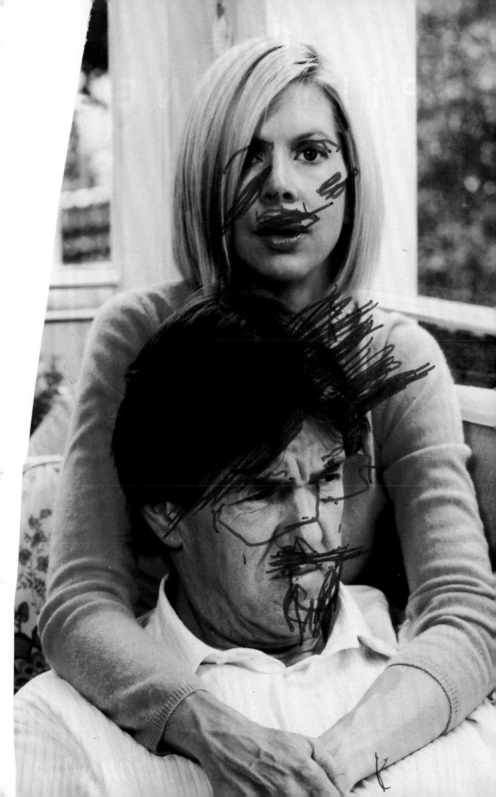

One of the things to have come out of the project is the *Dementia Font* – letters of the alphabet designed by service users of Petersfield Dementia Centre in collaboration with Bob and Roberta Smith. As well as creating a striking image that unites the contributions from the individual participants, the work also offers a way of considering what letters and words might look and 'feel' like when people lose parts of their memory or grasp of language. The font has been produced in the form of a poster, displayed around the London Underground.

Reminder 2006

Do you
your Mo

Hat ?
Slippers off
shoes on.

Bob and Roberta Smith
Notes to Self 2006
Photograph: Nicholas Moss

re intriguing aspects of the country ough its history, taking in everything m flamenco to Basque nationalism. er years working as the *Guardian's* drid correspondent, he has amassed easure trove of fascinating informa and anecdotes. *hosts of Spain* contains some real s, including the story of Hildegart riguez who was brought up by an itious mother to be a child prodigy. edited her first newspaper aged d founded the League for Sexual rm, only for her mother to shoot her in a jealous rage while she slept. emlett hits his stride, though, in his ing of the events surrounding the

Reminder 2006

is the Gas off?

Bob and Roberta Smith
Notes to Self 2006
Photograph:
Nicholas Moss

Images:
Reminder 2006

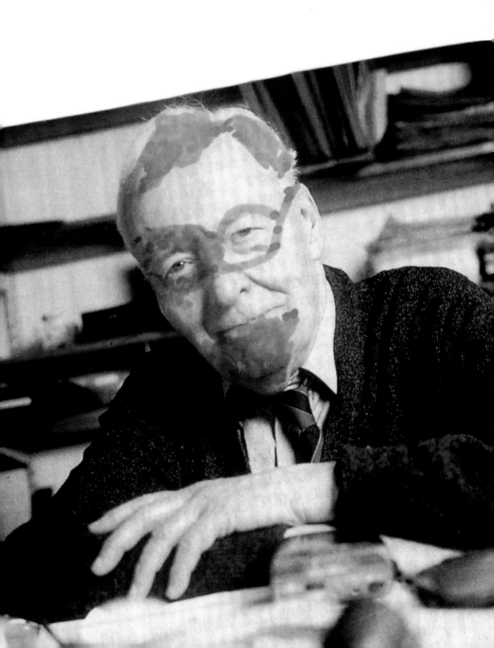

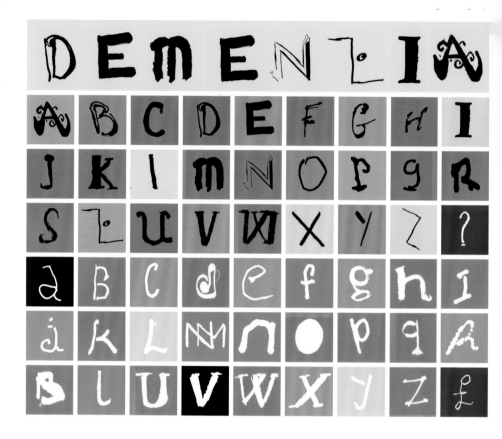

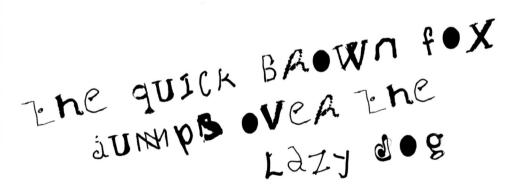

Bob and Roberta Smith,
immmprint, with people
from Petersfield Dementia
Centre
Dementia Font 2006

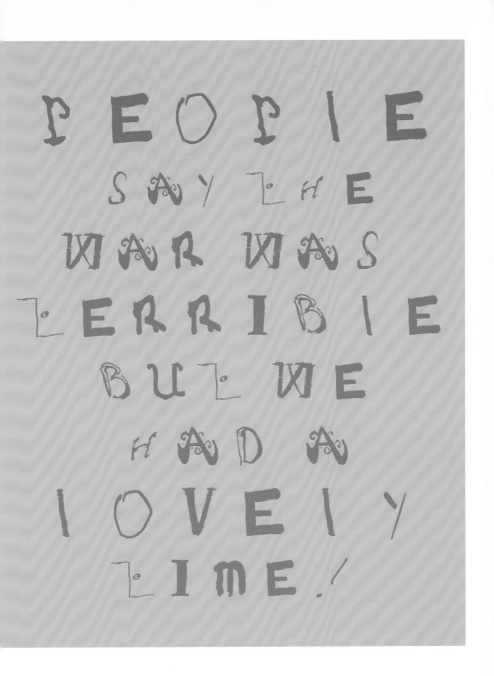

PEOPLE SAY THE WAR WAS TERRIBLE BUT WE HAD A LOVELY TIME!

Jessica Voorsanger
Joke by David Berlevy
Library Joke (detail) 2006
Photograph: Nicholas Moss

124

WHAT'S SO FUNNY?

Artist:
JESSICA VOORSANGER

with

Staff and service users of Waltham Forest
Day Services and Waltham Forest Primary
Care Trust

ne library the

I asked the

had any books

he said no

used to borrow

er return them

© db 2006

What's So Funny? 2006
Video still: Polly Brannan

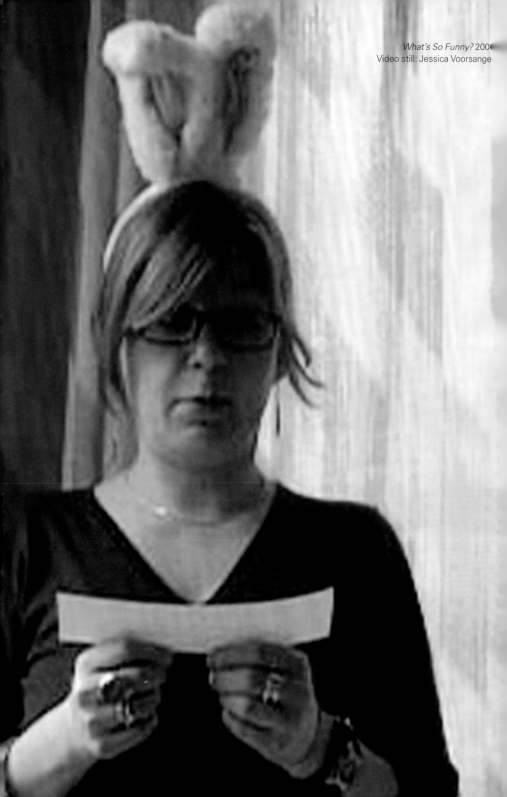

A horse walks into a bar. The barman asks: 'Hey, why the long face?'

The paradox of comedy is the contrast between the performer's private agony and the laughter in the stalls. Telling a joke and taking centre stage is fraught with risks. Perhaps these conditions allow serious issues to find a voice through humour – laughter releases us from personal inhibitions and frees us to talk about society's taboos.

Jessica Voorsanger has been asking staff and service users across Waltham Forest: 'What's So Funny?' With the intention of exploring comedy through the subject of mental health, a borough-wide mail out invited people to contribute their funny stories and favourite jokes. These have developed through project sessions, with people sharing their jokes and performing comic sketches and scenarios.

Voorsanger is interested in the idea of comedy as a form of escapism and its ability to affect our mood or change our state of mind. Whether stand up, slapstick, parody, irony or wordplay, humour permeates our daily lives and contributes to our means of communication with others. While one joke can leave us reeling with laughter, another only arouses indifference or may even cause offence.

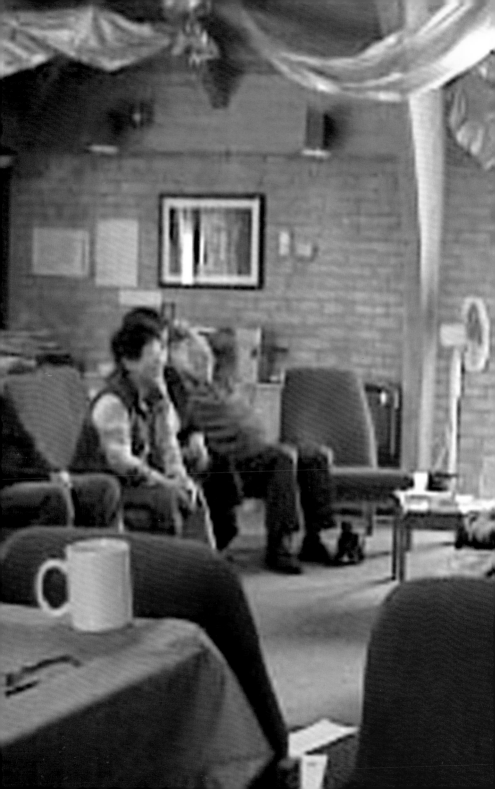

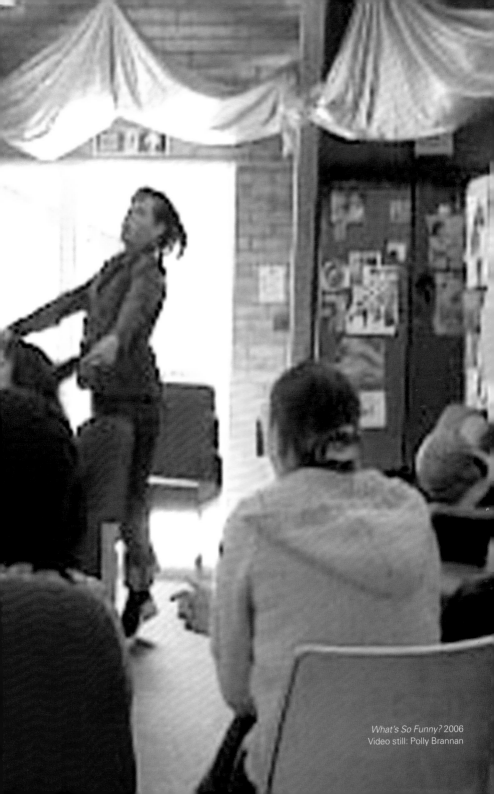

The Library
University College for the Creative Arts
at Epsom and Farnham

Jessica Voorsange
What's So Funny
200
Event publicity poster

There are parallels between Voorsanger's own practice, which explores the notion of 'celebrity' and of celebrities' fans – their unceasing adoration and unrequited love – and how we use humour to gain attention, affection and acceptance from those around us.

With a view to widening the project, Voorsanger continued to ask 'What's So Funny?' with contributions solicited by means of postcards distributed throughout the London Underground, and a stand-up event with professional comedians that launched the *Hearing Voices, Seeing Things* project at the Serpentine Gallery.

Jessica Voorsanger
What's So Funny?
2006
Postcard

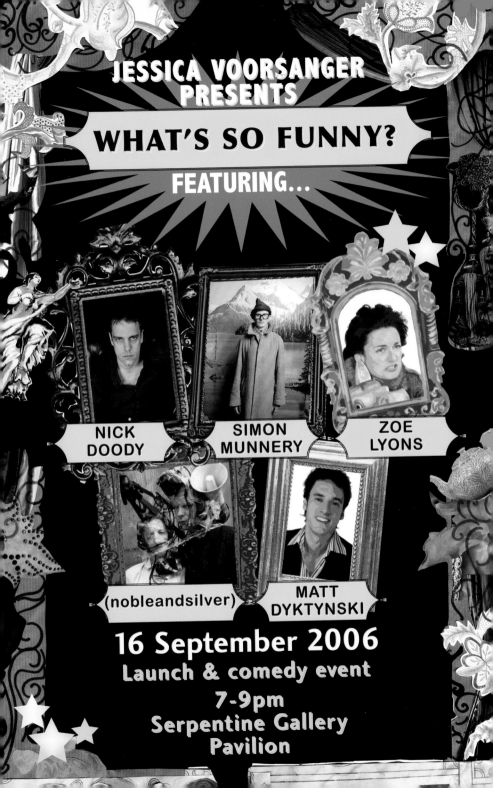

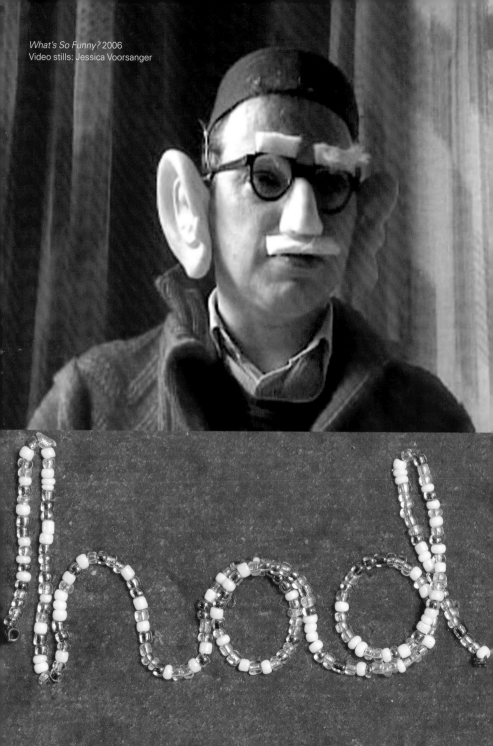

What's So Funny? 2006
Video stills: Jessica Voorsanger

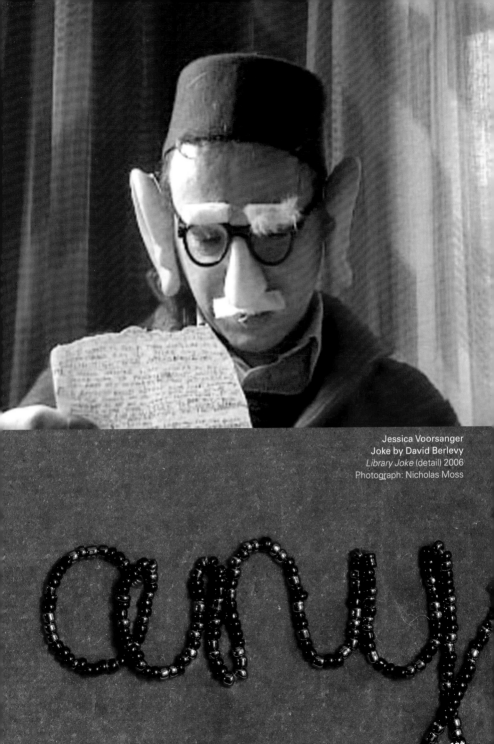

Jessica Voorsanger
Joke by David Berlevy
Library Joke (detail) 2006
Photograph: Nicholas Moss

ARTISTS'
BIOGRAPHIES

Mel Brimfield is an artist and curator. She is involved in numerous cross-discipline collaborative projects in the fields of visual arts, theatre and comedy, incorporating performance events, publications and radio broadcasts. She often works together with Sally O'Reilly on projects.

Karen Densham is an artist based in Ipswich. Her work investigates language through ceramics, found objects, painting, drawing, video and installations. She has exhibited in the UK and her work is included in collections in the UK, Japan and Hungary. She is also co-founder of the Ronald Jugg Gallery, Ipswich.

Mandy Lee Jandrell is a South African artist based in London. Working between tourist snapshots and the documentary image, Jandrell's practice explores leisure environments such as theme parks and recreations of historical sites around the world. She has exhibited in solo and group exhibitions in the UK and South Africa.

Andy Lawson is an artist based in East London. Sourcing material in the local area, he amasses the collections that form a major part of his practice. In addition to this he is a project co-ordinator for primary school art projects and a part-time lecturer at London Metropolitan University.

Victor Mount is an artist living in London. His work involves events, installations, performances and occasional publications. Recent solo exhibitions include *Hospitality Complex* at Unit 2 Gallery, London; *History in The Making – A Retrospective*, at The Metropole Galleries, Folkestone; and *Say No To Art*, at Flowers Central, London.

Sally O'Reilly contributes regularly to a number of art publications and has written numerous catalogues essays. She organises interdisciplinary performance events and presents performative lectures in universities around the UK. She is also co-editor of *Implicasphere*, a broadsheet publication that brings together 'esoterica' on themes such as 'string' and 'the nose'.

Bob and Roberta Smith is an artist and Co-director of The Leytonstone Center of Contemporary Art (LCCA). Musing on art, politics and popular culture, Smith hand paints slogans with his unique lettering style on banners and discarded wooden boards. He has exhibited internationally, including his amnesty on bad art at Pierogi Gallery, New York, 2002. Bob and Roberta Smith is represented by Hales Gallery.

Jessica Voorsanger is an American artist living in London. She makes work exploring celebrity, obsession, fans and media representation by means of video, performance, mail art, installation and painting. She has had solo exhibitions in London, New York, Edinburgh, Berlin and Turin. She is Co-director of the LCCA.